Francesco Bonami

KU-612-659

GABRIELE
BASILICO 55

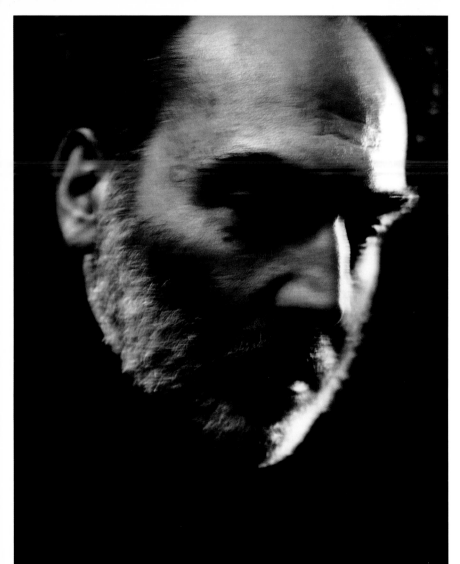

2.3

Gabriele Basilico doesn't like to travel, and yet his photographs describe an endless panorama of places. He likes cities, factories, structures; yet he represents them as abandoned, empty, useless. In this age of velocity, Basilico praises and practises slowness. He tries to defy the speed that is part of our contemporary world and slow down reality to a point of stillness in order to make sense of it.

His photographs evoke De Chirico's paintings or Antonioni's films, where lightness and luminosity co-exist alongside the existential mood that is revealed by the images. Perhaps Gabriele Basilico's greatest achievement has been to combine an existential spirit with a mind that has developed in dogmatic and ideological times. He manages to produce a unique vision that remains purely documentary while simultaneously describing the symptoms and psychology of our contemporary world.

The late 1960s and the 1970s saw the end of the first postwar utopia, with the student revolution that spread from Paris to Germany, and Berkeley to Rome. Western societies' beliefs and lifestyles were shattered. Basilico seemed to be aware that the prevailing creative mood would not reflect clearly the deep social, economic and political crisis affecting Italian society at that time. His attention turned towards the structures, factories and office buildings that symbolized both the energy behind the so-called Italian Miracle and the conservative forces that would change the miracle into a tragic disappointment, with the emergence and the actions of several terrorist groups on the fringes of an authoritarian regime. All his images contained both the austerity of official monuments and the echoes of crowds of workers fighting against those monuments. Basilico's work is not a celebration of architecture and its

symbolic value, but a discourse about the aesthetic value of architecture and the constant tension between this and its social function. While many of his colleagues at that time were making the individual the subject of their work, Basilico was concentrating on the absence of people as a phenomenon highlighting the success or failure of cities, houses and architects in their effort to serve mankind.

While other Italian photographers of the 1970s, such as Avigdor or Luigi Ghirri, were pursuing a more Italian idiom by indulging in a warmer light and atmosphere, Basilico realized that the way to escape the simplified Italian style of the historical narrative was to follow the same path as Eugène Atget or Walker Evans: to strip bare the urban context in order to reveal the pure structure of a city. People transform or affect the body and the psychology of a city. Basilico's images, seeking the pure id of the metropolis, town or village, lack the energy of social activity. He searches for the building that – to paraphrase Roland Barthes in his seminal book *Camera Lucida* (1981) – is not just a building but a just building.

Most of Basilico's subjects are cityscapes, residential buildings or factories. He rarely approaches landscape as a separate entity from the surrounding urban context, yet his gaze is not that of a jaded metropolitan individual. He behaves more like a pilgrim, migrating from one city to another, so that landscape is simply a transitional moment, a means of getting from one urban situation to the next.

Gabriele Basilico's work embodies silence. His pictures rarely feature people, yet their presence is implied; it is this small difference that makes Basilico's

work quite unique. To say that nobody is around does not exactly explain what the viewer is looking at. We could be looking at a city under curfew; or a city gripped by plague, as in Albert Camus' masterpiece; or perhaps a city evacuated because of an imminent disaster. By maintaining this ambiguity, Basilico does not allow the viewer to take anything for granted. All his photographs are an attempt to capture the spirit of the image, the building or the street. The absence of people represents the absence of time, the very symptom that defines architecture. Basilico is almost playing the role of a visual psychotherapist: the photograph is a kind of couch, its subject a patient waiting to be analysed. Unlike the photography of Cartier-Bresson, his pictures do not capture the decisive moment but describe how we would feel if the earth stood still at this very moment.

Like all artists, architects and writers who experienced Italy's political complexities during the 1970s, Basilico adheres to a specific methodology, focusing on an ideological approach to aesthetic practice and refusing a classical representation of reality. In spite of this, he cannot completely forgo his devotion to landscape as a classical subject. For him, photography remains a tool with which to document and represent society, to express truth; aesthetics are secondary.

The reason for this may perhaps be found in the city where Basilico has lived most of his life, Milan. This city was, and still is, the commercial and economic centre of Italy, yet it has never achieved the desired status of international metropolis. While architecture was a major concern in Milan prior to World War II and during the 1950s and 1960s, political intrigue and endless bureaucracy have prevented the construction of any major or

internationally renowned buildings. Milan presents a network of middle-class neighbourhoods situated right next to former industrial sites and neglected parts of the city.

For Basilico, this situation, while not particularly visually inspiring, was a pretext for analysing, via the camera, what he saw as a dysfunctional architectural culture. It was a culture that never developed its own programme but instead always relied on political intrigues and corruption to become a reality. Basilico did not attempt to represent Milan as an international metropolis, but instead focused on the disappointed attitude of his home city. He went out to capture those moments when Milan appeared in its true light – as a provincial city, deserted in the early evening, a city too large for its consciousness. Milan's consciousness is that of a productive city, a more cosmopolitan version of small northern Italian towns, wealthy but conservative. Its buildings reveal their austere dignity but also all their sadness, like penniless old aristocrats standing at a bus stop.

Basilico's images have the same feeling as some of the opening pages of Italo Calvino's books, such as *Marcovaldo* or *La giornata di uno scrutatore* ('An Election Scrutineer's Day'). Calvino's words are, on the surface, elegant; but below lies the disappointment of a community becoming aware of having missed the opportunity to transform itself into a mature modern society.

Basilico seems to have derived something from Calvino's vision, in the way he looks at places where certain expectations were built up only to be destroyed in small daily disappointments. Nevertheless, his approach is not pessimistic but realistic, a kind of visual awareness that architecture is the reflection of

individual ambition combined with civic pride – both qualities that have been lacking in Italy in the last three decades. That is why, when his work takes him away from his city, often to the north of Europe, his images have a different openness, as if he were suddenly able to breathe more easily. There is no difference in quality between the images taken in Milan or Italy and those in the north of Europe, but the feeling of claustrophobia that we experience in Italy is diluted by a certain amount of what could be termed visual hope, which seems to be embodied by northern European architecture. Whereas in Italy, therefore, most modern architecture seems to reflect a degree of moral decay in the society it should serve, in such places as Germany, France or the Netherlands the buildings try to mirror the energy of a community, its social pride. The individual elements of a city are not just seen as containers for each citizen's private desires, frustrations, ambitions or disappointments, but should contribute to bringing about a better quality of life. Basilico's photography responds to this divergence between Italy and the rest of Europe, between jaded negligence and excessive utopianism.

Throughout the history of art, landscape artists have always played a political role. Whether looking at nature or at the social structure of a city, the landscape artist's purpose was to offer the viewer a specific, documented reflection on the historical context and the contemporary nature of cities and landscapes. If people were artists' preferred subjects up until the early seventeenth century, from the birth of the Baroque period at this time, space and architecture assumed the central role in the representation of reality. To say that Basilico is a 'Baroque' artist would be misleading, but to analyse his work simply from the point of view of photography could be equally so. The roots of Basilico's work do not lie in his first photographs of the early 1970s; they can

be traced back to the eighteenth century and the painting of Bernardo Bellotto, to Bellotto's views of the German city of Dresden in particular. Bellotto was a nephew of Giovanni Antonio Canale, better known as Canaletto. Rather than focus on the object of his uncle's obsession, Venice, he went to northern Europe. There his work moved away from the ephemeral atmosphere of the Venetian lagoon to embrace a more analytical vision, in which the light in his painting is more a reflection of the religious and political atmosphere of the time than the symbolic evocation of Venice's mythical character. As Bellotto did in the eighteenth century, so Basilico grafts the melancholic beauty of Italian culture on to the bleakness of the northern European sky. The results are images that seem to yearn for a long-delayed transformation of the photographer's motherland.

The impact of northern European light on buildings showed Basilico how he could define his vision more precisely and in a more austere way. The polluted, melancholic grey sky of Milan was replaced by the heroic clouds hovering over Dutch and German landscapes. This new atmosphere was to transform the approach that Basilico was later to take to photography, in the same way that it transformed Bellotto's attitude towards painting. Both film and canvas effectively become a fourth dimension, in which time is not frozen but isolated together with the image, and both are allowed by the artist to live a kind of parallel life.

Basilico's methodology reflects a pragmatic attitude towards the subject typical of the left-wing Italian intelligentsia of the 1970s. His creative approach is always subservient to the document he is producing; his artwork cannot be separated from its social function as a clinical, warts-and-all representation

of the Italian urban context. Writers such as Paolo Volponi, Elio Vittorini and even Italo Calvino mirror Basilico's way of representing Italian social reality. In architecture, Giancarlo De Carlo, who based his entire career on defining architecture as social commitment, matches Basilico's attempt to use and define photography. Yet Basilico's European wanderings have forced him to create a series of visual analogies to the Italian reality he represents. In this way, he has remained an Italian intellectual while being transformed into a European photographer by his own accurate analysis of the European urban landscape. His career runs parallel to those of such people as Bernd and Hilla Becher, Thomas Struth or Andreas Gursky, whose work has perhaps been more instrumental in blurring the boundaries between photography and contemporary art.

A closer analysis of the distant relationship between Basilico and these German photographers might reveal more about his distinctive approach to the photographic representation of architecture and landscape. Although he shares some techniques with the Düsseldorf school, Basilico has never accepted the transformation of the image content into a signifier, in the manner of the German photographers. He also disagrees with altering the scale of an image with technical manipulation. Basilico sees himself primarily as a photographer; in Italy this means that he belongs to a specific field and category that has only recently begun to be assimilated into the larger field of contemporary art. The German photographers understood that in order to escape the photography ghetto, they needed to break down its dogmas. Basilico never accepted this idea, perhaps believing that these dogmas helped him to remain more faithful to his subjects, more objective in relation to the content of his images.

However, he undoubtedly follows closely the Bechers' typological approach to the photographic image. Their idea of extracting architectural structures from the landscape to transform them into sculptural images differs somewhat from Basilico's style of working. The Bechers seem to decontextualize an image in order to use the photograph as a means of focusing attention on sculptural form, be it a gas power plant or a water tower. For Basilico, however, the medium functions as a membrane that connects different parts of the subject within the overall frame. The work is always a fragment of something else, something larger and the vehicle of a broader content. In the Bechers' work, there is no narrative. Whereas their vision is that of an industrial archaeologist, who looks at an object devoid of any contemporary aspect, each of Basilico's buildings bears the scars of the present, the immediacy of a painful abandonment. If Hilla and Bernd Becher approach photography from a bodily perspective, Basilico looks more into the psychology of the subject. Each of the buildings that Basilico selects for his images seems to represent the architectural symptom of a specific economic class or neighbourhood. Waiting for the people to disappear from a building before taking the photograph, his intention is to identify the symptom among other symptoms – other buildings, streets, bridges – in order eventually to discover the causes that produced them: economic transformation, gentrification, urban development, decay, history. Basilico's architecture resembles a mirage, appearing on the horizon not as the result of a methodical search but in the manner of a sudden revelation.

Although painting is a constant point of reference for Basilico, he never attempts to act like a painter in terms of technique or scale. In this way, his work differs from that of Thomas Struth, whose images often express a

longing for the painted image in their composition and use of colour. Struth's work, moreover, deals constantly with the deceptions of representation. His presence is always felt in his images. By contrast, Basilico's photographs are a denial of the artist's presence. His eye is the eye of one of Van Ruisdael's birds. The seventeenth-century Dutch landscapist used birds in order to create a sense of distance and spatial depth; yet, without becoming the subject, the birds are also the only dynamic presence in the canvas. This distance equates with the one Basilico creates between himself and the camera he is using.

In Basilico's photographs the scale of human feelings remains intact, as does the scale of each building or each street. Andreas Gursky, on the other hand, appears to keep the world at an almost godlike distance. His angle on reality is not about the individual subject but about a certain idea of totality. Gursky's work reflects the fear of being touched that Elias Canetti described so well in his *Crowds and Power* (1960). In contrast, while not approaching the subject closer than necessary, Basilico reaches the point where, even if the subject is not touched, it can be felt. If Gursky can be said to escape involvement with the masses he observes, Basilico's camera sits on the edge between memory and commitment, politics and emotion.

Among the commissions that Basilico has undertaken in the last decade, two have a particular relevance: the photographs of Beirut from 1991, and 'Sezioni del paesaggio italiano' ('Cross-sections from the Italian Landscape'), presented in 1996 at the Venice Biennale of Architecture in a joint project with the Italian architect Stefano Boeri. In both cases, Basilico aimed to challenge our conventional perceptions of the places he had to represent, whether a bombed-out

building in Beirut, or an anonymous shopping mall or housing development of the kind that has corrupted the beauty of the Italian landscape in the last forty years. Basilico looked at the ugliness both of historical events, such as the civil war in the Lebanon, and of the Italian provincial suburbs. Similarly, the Italian film director and poet Pier Paolo Pasolini (1922–75) analysed the tragedies caused by modern Western society in such places as India or Africa, as well as the hybridization and corruption of the Italian underclass and agricultural economy during the rampant industrialization of the 1960s and 1970s. The photographs of the 'Sezioni del paesaggio italiano', which chronicle Basilico's pilgrimage through six 'sections' of the Italian landscape (between Milan and Como; Venice and Treviso; Florence and Pistoia; Rimini and San Marino; Naples and Caserta; Gioia Tauro and Siderno), conjure up images from Pasolini's *Uccellacci e uccellini* (*Hawks and Sparrows*) of 1962. In this film, the two main characters wander about a countryside that is in a state of continuous and tragic transformation, in which the identity and dignity of the farms is threatened by the spread of breeze-block houses and ugly polluting factories. Like Basilico's images, the film does not focus on the representation of a disaster, but instead attempts to salvage the remains of the individual's autonomy and independence. Both Pasolini and Basilico want to participate, even if they are disappointed about the rescue of what they believe is still hidden in the decay of contemporary society.

In 1991 Basilico was invited to Beirut with other photographers to document the city just after the civil war had ended, and just before a massive programme of rebuilding began, replacing the noise of cannons and machine guns with the equally excruciating noise of pneumatic drills, bulldozers and cranes. Again, Basilico did not take the easy road of a simple commentary, but tried to

approach the stage before him as an archaeologist might, looking at the ancient ruins of Petra in Jordan for the first time. If Beirut were abandoned, it could become the Petra or the Pompeii of the year 4000. No matter how it comes about, in Basilico's eyes destruction has the same consequences as the slow and unavoidable erosion of time.

The Beirut photographs are not an indictment of war but a poetic reflection of the relentless folly of mankind that can still create tragic but beautiful images out of destruction and hate. Every image is a meditation on the silence of time that each ruin carries within itself. For Basilico, beauty always contains a dark side that belongs to history's deception, to its capacity to transform human tragedies into a monument, as in the marvel of the Colosseum's architecture, which conceals the brutality of its function. The Parthenon in Athens owes its present appearance not to the relentless action of time, but to the cannon-balls of the Venetian army that bombed it at the end of the seventeenth century because the Turks were using it to store explosives and ammunition. In the same way, the buildings of Beirut that Basilico has isolated in their own dignity are nothing less than contemporary Parthenons, Colosseums, Herculaneums — symbols and ruins of a different history in which hope, religion, corruption and politics appear more powerful than earthquakes, volcanoes or senseless weapons.

The images of a city and the images of time are so intertwined that it is impossible to talk about one without the other. Modern time is a metropolitan time, no longer related to the rhythm of nature but to the nature of industrial production and communication. These are photographs of modern time: they have a rhythm that is linked to the rhythm of the metropolis. They need to wait for the moment

when modern time allows the streets to be empty, the people to be inside their homes. Time passes and repeats itself in metropolitan life; in repeating itself it shapes the urban condition and its contents. The photograph tries to understand this constant process and to absorb it into its subjects, while trying to connect both to the future.

Purely as a photographer, Basilico runs the risk of going against the rule of his profession that requires the photographer to be in the right place at the right time. His work is not about 'the moment'; it is about the effort to create a large jigsaw puzzle of moments that will eventually reveal a complete 'scene'. In fact his work functions – and succeeds – precisely because of his consistent belated arrival in the ultimate attempt to reach a sort of suspension of time, in which correctness and truth to reality can be delivered to the viewer. In a society dominated by subjects that become their own 'object of desire', this is a very brave, even desperate, attempt.

In addition to Pasolini, another Italian film-maker, Marco Ferreri (1928–97), has also been important in Basilico's work. Ferreri's manner of filming with a lock-down frame similarly aimed to give an idea of self-contained space, a space that is not defined by the frame but that defines it. Basilico and Ferreri shared the idea of a space that has a kind of democracy in its structure, that doesn't direct the viewer towards a specific point of view but that expresses the balance of an objective gaze. A film such as *L'Ultima donna* ('The Last Woman') (1976) describes the crisis of a contemporary relationship between a man and a woman in an industrial and suburban environment that could have come from any of Basilico's photographs. Ferreri's melancholic relationship with the pristine, perfect shape of industrial architecture mirrored Basilico's silent dialogue

with his subjects. This industrial architecture is seen as both cathedral and monster, demanding worship while at the same time spreading intimidation. If Ferreri longed for the last pure woman as the chance to save mankind, Basilico has perhaps been longing for the pure building, as the last chance to preserve the role of architecture as the definitive tool for shaping and saving relationships in contemporary society.

Worker, Milan, Italy, 1973. Milan, the city where I was born and grew up, has been and still is a place I like to explore. In the 1970s, when I was beginning to experiment with photography, I used to enjoy wandering round its outlying districts, mixing shots of the city landscape with portraits of people I happened to come across in the street. When I started, I saw photography primarily as social reportage, but architecture and landscape gradually took over and became my main fields of interest.

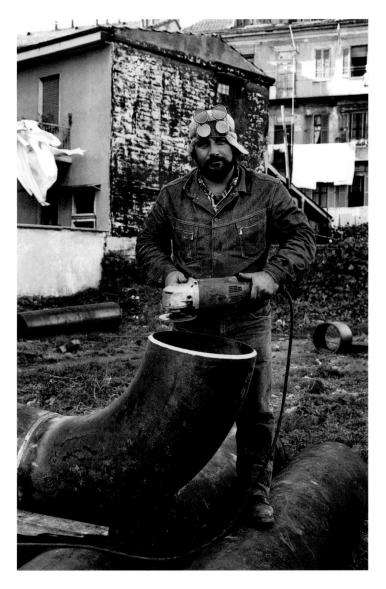

Milan, Italy, 1978. Three funnels, the chimneys of the power plant at Milan's Garibaldi Station, have become a metaphor for my Milanese industrial landscape, in terms of both the subject and its narrative form. I liked to approach architectural subjects, especially industrial architecture, as if they were people, detached from their immediate context by strong lighting.

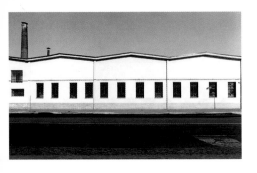
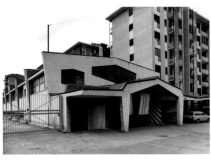

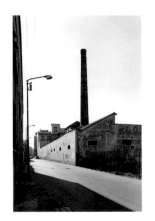
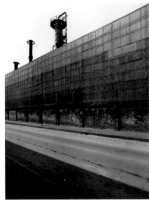
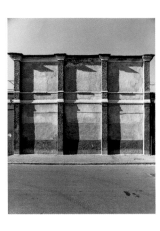

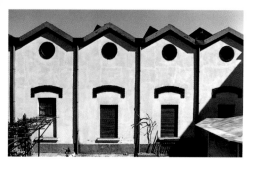
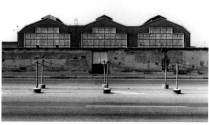

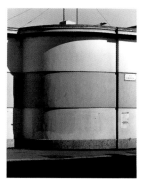
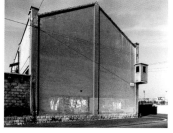

(previous page) **Portraits of Factories, Milan, Italy, 1978–80.** Over a period of almost three years I carried out a long photographic exercise on the subject of Milan's industrial areas. I had been experimenting with reportage, but with 'Portraits of Factories' I radically changed the way I took photographs. People disappeared from my images, and space, buildings and places became the central subjects of my work, very often in isolation. From 'Portraits of Factories' onwards, all my attention was transferred to architecture or to urban and industrial landscapes.

Milan, Italy, 1980. In the work I did in the early 1980s, the strong, clear light of slightly windy days served, like empty space, as an invaluable working tool, allowing me to read architectural forms as though they were on a stage. It was a stage the actors had just left, or to which they were about to return, leaving a sense of expectation in the air.

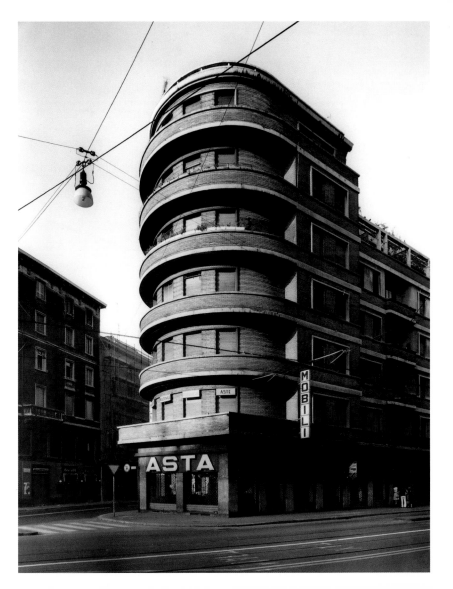

Naples, Italy, 1982. My interpretation of architecture is often physical, almost anthropomorphic, in the sense that a building is sometimes seen as a living body. The Central Post Office in Naples, designed by Giuseppe Vaccaro, an architect of the 1930s, appears here like a muscle flexing in dynamic movement. I have always found Vaccaro's visual expressiveness highly engaging, and I have continued to photograph his works over the years. A small book entitled *Giuseppe Vaccaro*, paying homage to this little-known master, was published in 2000.

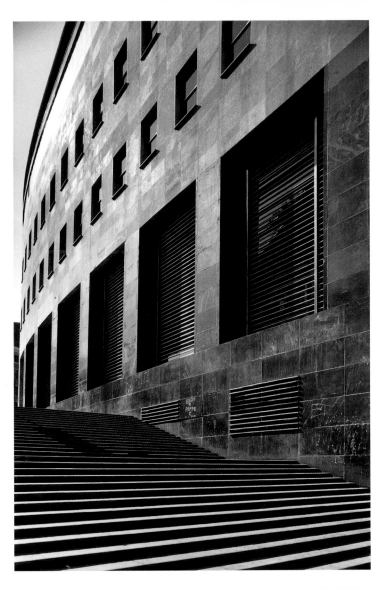

Naples, Italy, 1982. In 1982 I received my first public commission, to photograph a city (with absolute artistic freedom) for a collective project under the title 'Naples, a City by the Sea with a Port'. I decided to work on the relationship between architecture and the sea. In this image of the Maschio Angioino, an ancient fort overlooking the Marine Railway Station, its wider setting can barely be seen (on the horizon, to the left), and the whole space is occupied by the physical, almost animal, presence of the monumental construction, like an enormous elephant's foot resting on the earth.

Naples, Italy, 1982. My first opportunity to take photographs in a port was important to me, and taught me a lot. This image of the Marine Station in the Port of Naples marks the beginning of a long project on ports, in connection with which I travelled to many European cities, up to 1990 and later. The book *Porti di mare* (*Seaports*, 1990), a collection of the images I made on these journeys, was also an opportunity to make a cultural and geographical comparison between ports in the north and the south of Europe.

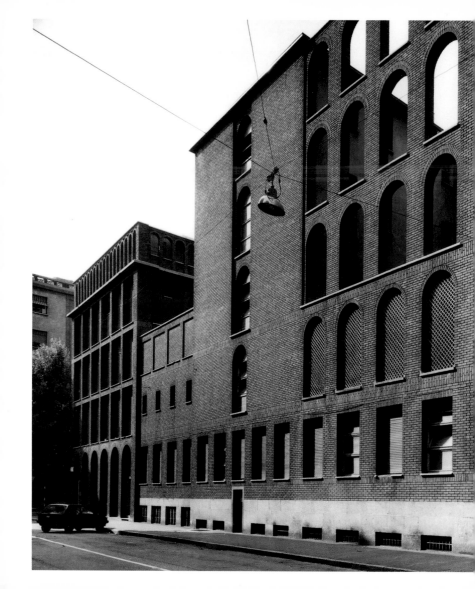

(previous page) Milan, Italy, 1983. An image of the Angelicum, designed by Giovanni Muzio and built in the 1930s. I devoted a long series of work to the Metaphysical architectural movement of that period, so called with obvious reference to the paintings of Giorgio de Chirico. It is entitled 'Immagini del novecento: architetture a Milano, 1919–39' ('Images of the Nineteenth Century: Architecture in Milan, 1919–39'); by using light and eliminating the city traffic, I tried to give an impression that time had been suspended.

Dieppe, France, 1984. In 1984 I was invited to take part in a photographic exercise organized by DATAR, the French regional planning authority. It was the century's largest landscape photography project, mounted by the French government as a way of presenting the idea of France's imagined geographical identity. My fascination with ports and harbours was the decisive factor in my choice of a topic, and under the title 'Bord de mer' ('Seaside'), I suggested the theme of a journey along the north coast of France.

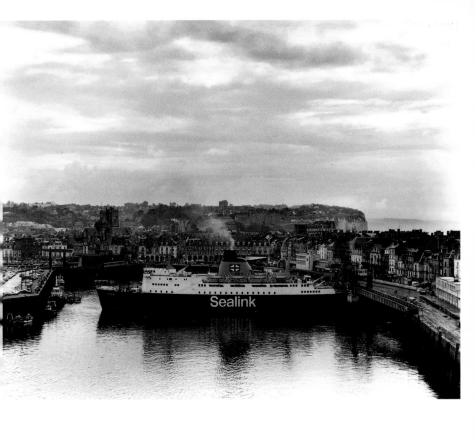

Boulogne-sur-Mer, France, 1984. The northern coasts of France are geograph-
ically diverse; tall cliffs rising straight from the sea alternate with vast beaches.
It is only the weather that is constant, and often implacably harsh. At Boulogne-
sur-Mer, one of the biggest fishing ports, I went to the beach on a cold, windy
day; the faint outlines of a factory and the handful of brave swimmers suddenly
gave me the feeling that I was among the survivors of some apocalyptic scenario.

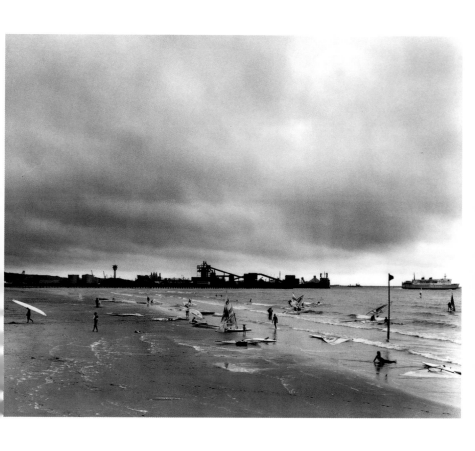

Boulogne-sur-Mer, France, 1984. The relationship between land and sea gives new importance to the idea of an edge or border. In this image, again made for DATAR, it is as if I were emphasizing the physical, aggressive aspect of this relationship. During the two years I spent in France, my perception of space broadened, and the traditional view, which until then had been an imposition, came to seem natural.

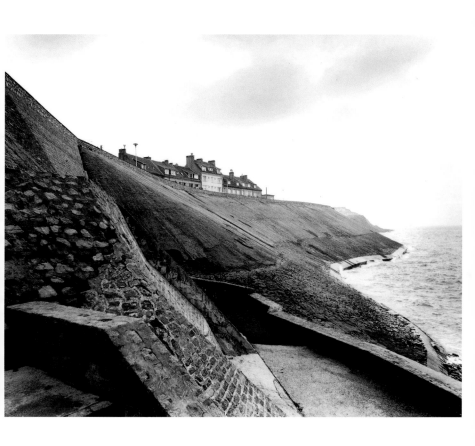

Le Touquet, France, 1984. In the late nineteenth century, Europe's coastal areas underwent a process of intensive and uncontrolled development that varied in character from one place to another, often with bizarre results. While I was in Le Touquet, in northern France, working on my photography commission for DATAR, I came across this amazing juxtaposition on the sea-front of two buildings from different periods, one in late nineteenth-century eclectic style, the other of an extreme rationality. An early foreshadowing of the language of deconstruction, perhaps?

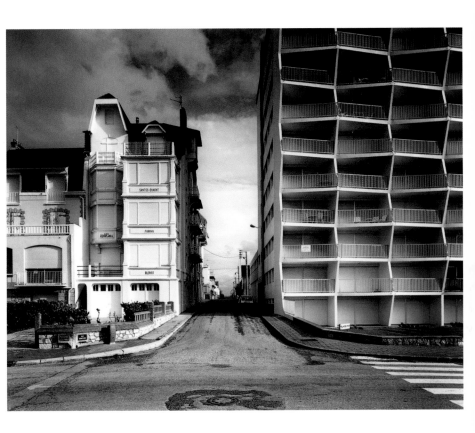

Dunkirk, France, 1984. This is perhaps one of the most romantic examples of all my landscape photography. The setting, with the long concrete dyke protecting the industrial area in the distance from the rough North Sea, and the evening light that produces the effect of a black-and-white engraving, with no intermediate tones, give the scene a dramatic, apocalyptic atmosphere.

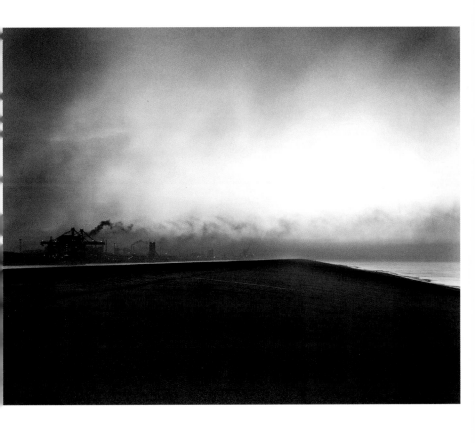

Dunkirk, France, 1984. On the huge jetty in the port of Dunkirk, I happened upon a row of small houses, all different. It seemed an appropriate reference to my architecture project. The buildings stand very still, like people in an empty square. They are waiting for something. They differ in type and character, like actors in a film, waiting for shooting to begin.

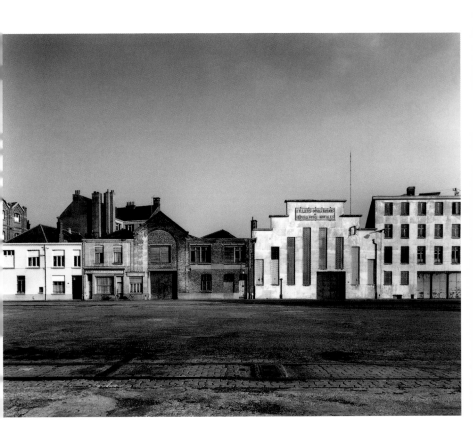

Calais, France, 1985. While I was taking photographs as part of my DATAR commission, the weather was often terrible. My daily struggle with wind, rain and cold changed my perception of the landscape, but it also forced me to accept it, and to look for a different narrative voice. There had been torrential rain in Calais that day, and it had given the road surface a magical shimmer.

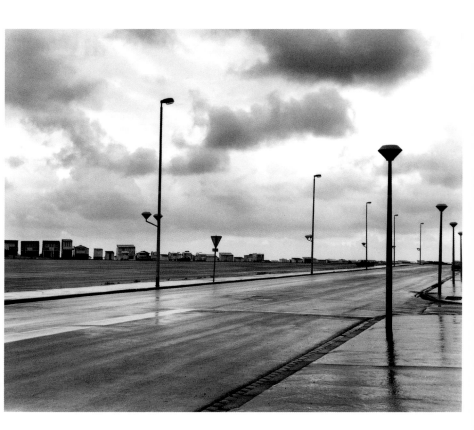

Le Tréport, France, 1985. Of all the photographs I took for DATAR, this is the one I like best. There's a lot I could say about it, but the word I prefer is contemplation. Contemplation means spending longer in the act of looking, oblivious of time, leaving behind the rapidity and the acrobatics of high-speed photography, allowing yourself to sink almost meditatively into the beauty of nature and dissolve into it.

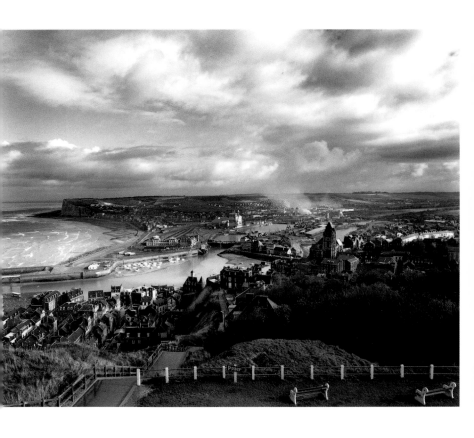

Ault, France, 1985. An old-fashioned shop sign caught my eye and became the centre of interest in a space that struck me as magical and comforting. In the background, between buildings that make a harmonious composition, can be seen the sea, as flat as in a painting, a subtle invitation to escape.

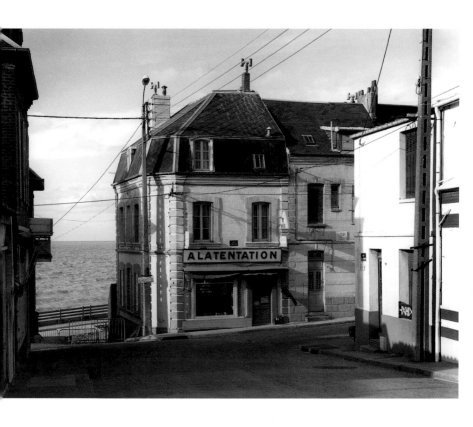

Merlimont Beach, France, 1985. During the two years I spent photographing the northern coasts of France, I discovered some aspects of landscape that were new to me. Far from depressing me, the sense of solitude that is an inextricable part of those vast spaces opened my eyes to their geography and the feeling of the infinite that landscape can evoke. I remember that when I took this photograph I had a nostalgic reminder of the main street imagery of Peter Bogdanovich's film *The Last Picture Show*.

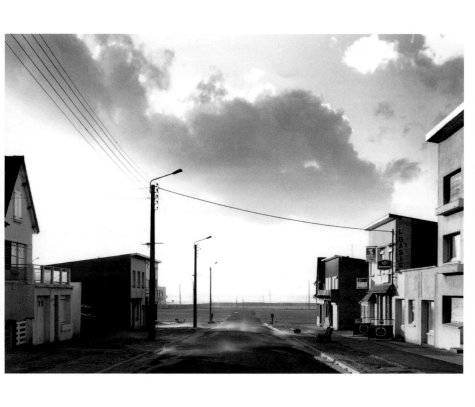

Trieste, Italy, 1985. The Ausonia public swimming pool in Trieste, a concrete platform suspended over the sea, built in the 1930s. I disagree with people who say there are no human beings in my photographs. My view is that they are always there, one way or another, but you don't see them: they're hidden and protected, or even present in a different time-scheme. In this photograph, on the other hand, people can be seen, but I like to think of them as absorbed into the concrete construction and forming part of it.

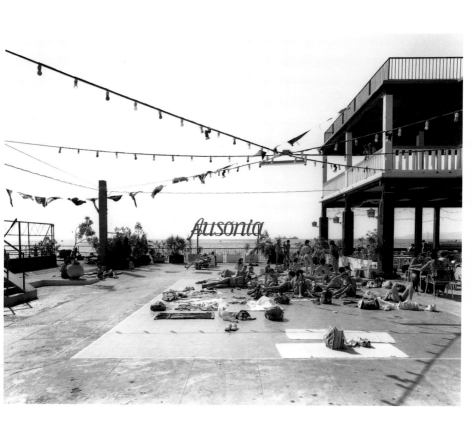

Genoa, Italy, 1985. Industrial activity, with its characteristic architectonic forms, has long been a source of fascination for me and almost always predominates in my work on ports. Here the panoramic, elevated angle offers a broader, more inclusive perspective, in which near and far are conflated and given equal importance. This has sometimes enabled me to create very balanced and elegant compositions.

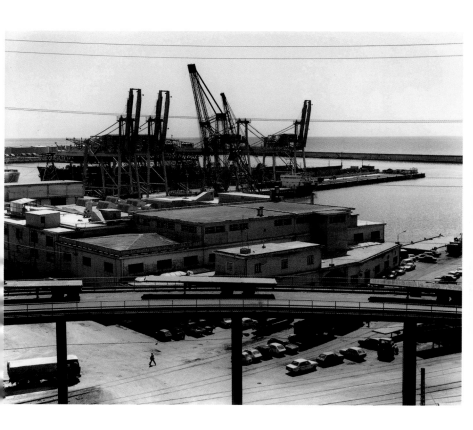

Dunkirk, France, 1985. If we go down to ground level from a high viewpoint that encourages contemplation and enter the scene itself, our dialogue with space and the live presences inhabiting it becomes more active and creative. In the port of Dunkirk I came upon a sight that reminded me of a set of Russian dolls. The angle chosen is from the base of a crane, identical to several others that stand out against the background like a ragged line of soldiers. The result is to make one read space in a circular way that effectively links foreground and background, and alters the apparently static nature of the image's perspective.

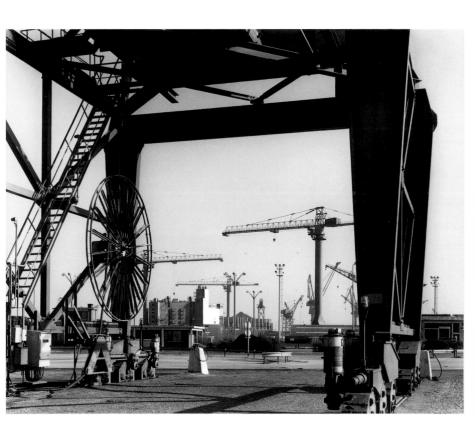

Lausanne, Switzerland, 1987. The city is like a machine, a complex, layered structure that is able to achieve form and balance even when it is the result of chance. A city's identity and vitality also derive from the fact that its paradoxes are unique. Here the bed of the River Flon becomes an industrial area, and a building supports the bridge that links the banks of the former river, all against the distant outline of the city.

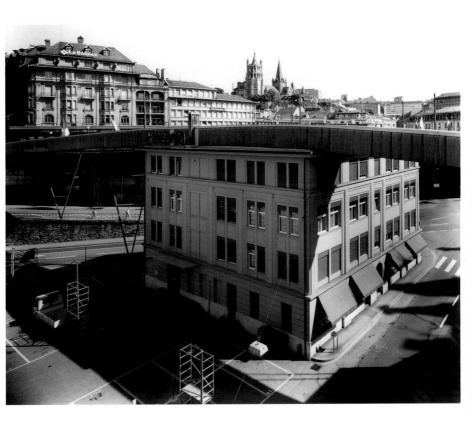

Lausanne, Switzerland, 1987. I have always been fascinated by street signs and I have often used electric cables, poles, lamp-posts, road markings and pedestrian crossings as a type of visual language. In my photographs, this ensemble of signs has frequently served as a new graphic device that one can use to reorganize space. It is like a spider's web superimposed on the city, either spoiling or reinforcing its appearance.

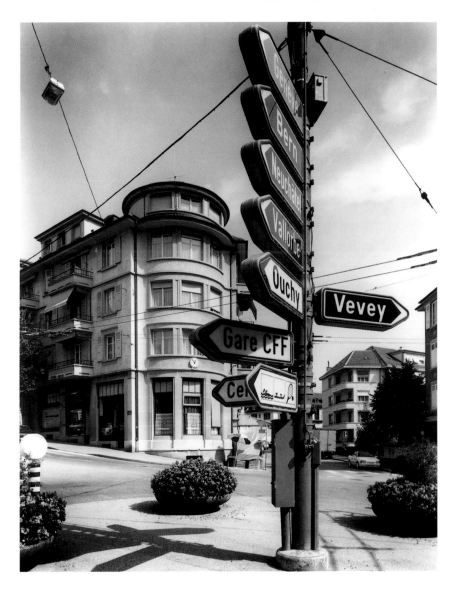

Antwerp, Belgium, 1988. While I was working alone in European ports, the image of a ship leaving port and sailing out to sea filled me with powerful feelings. This small ship came to symbolize ocean voyages, departures, the expectations of a journey into the unknown and nostalgia for what is being left behind.

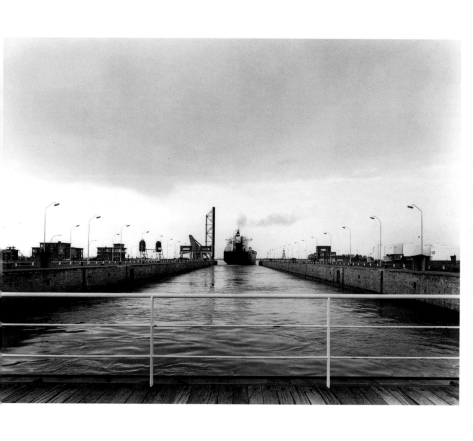

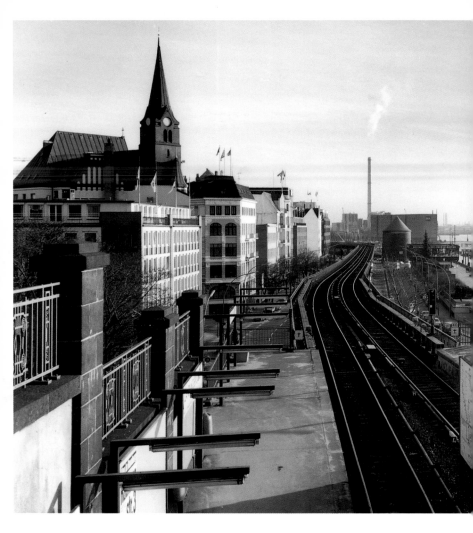

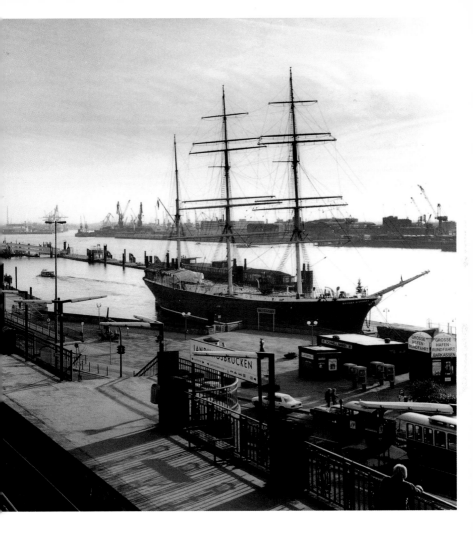

(previous page) Hamburg, Germany, 1988. What struck me most forcibly when I took this panoramic view of the port of Hamburg was the sense of timelessness. It was as if time had stopped. Even the photographer is often taken by surprise at the ambiguity of what he sees. In this image the railway line and its fixtures, and the movement of vehicles on the platform, are the only things that show we are in the present day, while the sailing ship and the church spire could belong to the nineteenth century.

Hamburg, Germany, 1988. The form space takes often produces theatrical images. The central position of the camera turns these two industrial buildings in the port of Hamburg into stage sets that frame, in the background, a series of cranes resembling an improbable group of warriors waiting in the wings.

Milan, Italy, 1989. The city is a living, breathing body, and its buildings, like organs or anatomical details, are part of that body. The Pirelli Tower, designed by Gio Ponti in the 1950s, is one of the most popular buildings in Milan and, as such, it has become almost an emblem of the city. It is a building I like very much, and I have photographed it from different angles. This image is framed so that the tower is cut off cleanly half-way up, emphasizing its physical strength and upward thrust towards the sky.

Rome, Italy, 1989. One of the things that most fascinates me about Rome is its theatricality. In every part of the city, fragments of history, of unparalleled depth and richness, emerge as if on to a stage. Sometimes they take you by surprise, round a corner at the end of a series of alleyways, or, like the Temple of Minerva, they stand like a symmetrical stage set between the newer buildings that flank them.

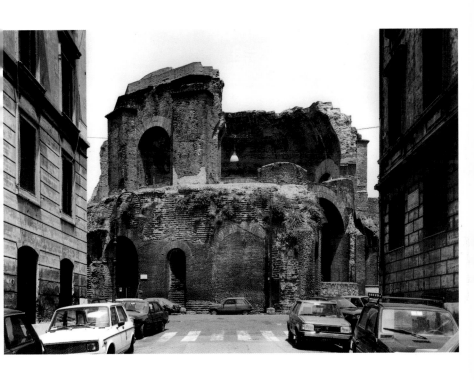

Barcelona, Spain, 1990. This photograph was taken in an out-of-the-way place near the port of Barcelona. It is a typical borderline zone, where the texture of the city, formless and impermanent, reminds us that we are on a line separating what is behind the buildings from the emptiness in front of them. These border-lands (which make me think of the way waters mix at the mouth of a river) are one of the subjects I explore most frequently in my work.

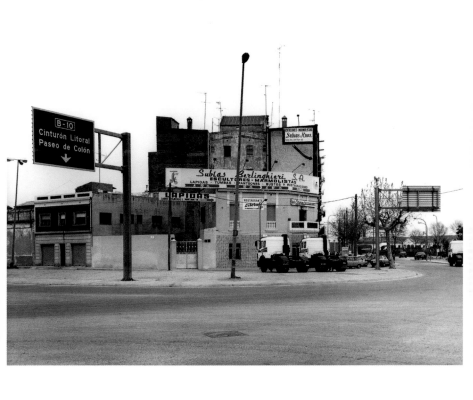

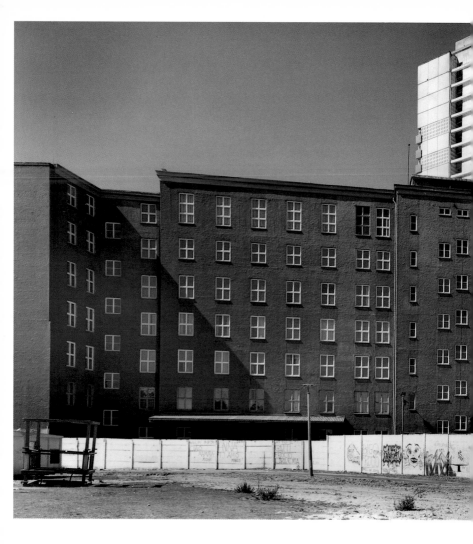

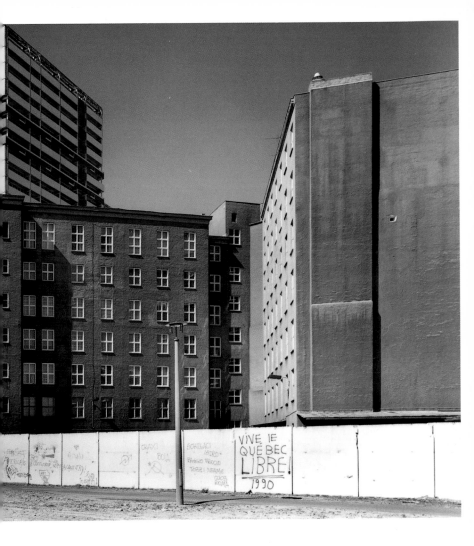

(previous page) Berlin, Germany, 1990. A view of Berlin taken a few months after the Wall came down. The buildings in the East rise in an imposing mass, as if eager to cross the flimsy barrier of what is left of the Wall. The scene had an almost symbolic value, and it was inevitable that I would photograph it.

Beirut, Lebanon, 1991. I went to Beirut shortly after the end of a war that had lasted many years. The centre of the city had come under heavy attack, and all the residents had left. Some aerial bombardment and an almost continual series of battles with small arms had superficially damaged the buildings in the centre, but had left them otherwise intact, so that their structure was recognizable. It was a city that was wounded, but not fatally, grimly hanging on in the hope of being rebuilt. This street, with the sun reflected from its surface, is emblematic.

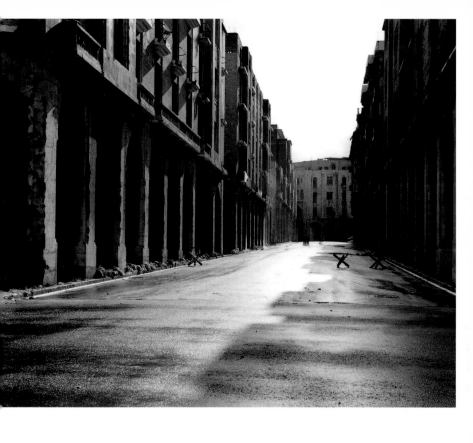

Beirut, Lebanon, 1991. The lack of life or traffic, and the silence, made it possible to pay close attention to the design of the buildings and their war-torn surfaces. I felt like an archaeologist of the present, and photography helped me to reveal and reconstruct an equilibrium that appeared to have been lost, destroyed by the agonizing events of the war.

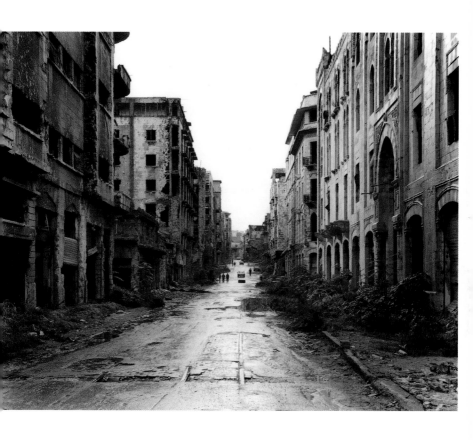

Beirut, Lebanon, 1991. A Lebanese friend persuaded me to look for a high angle, and this marked a decisive point in my photographic project in Beirut. From that particular point, the city made me think about the geological complexity that unites all Mediterranean cities in a single grand design. In the far distance one can sense the life and movement that have disappeared from the historic centre, like an unstoppable energy that will eventually heal the most visible wounds.

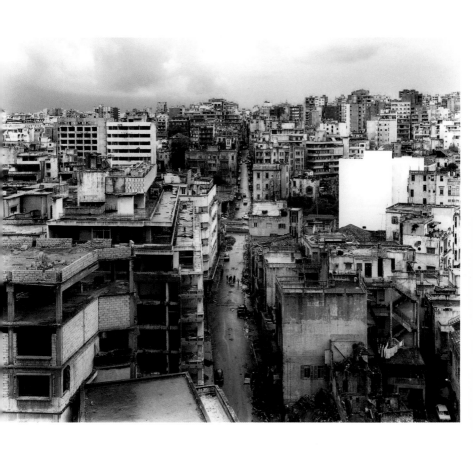

Bilbao, Spain, 1993. As a rule, I find it easiest to discover the unique character of a place through its architectural forms and the visual qualities of their details. In the port of Bilbao, however, it was the setting – the river sparkling in the sun, the shipyard, the surgical wound almost like an amputation in the ground – that offered me a different way of reading the scene's essential corporeality.

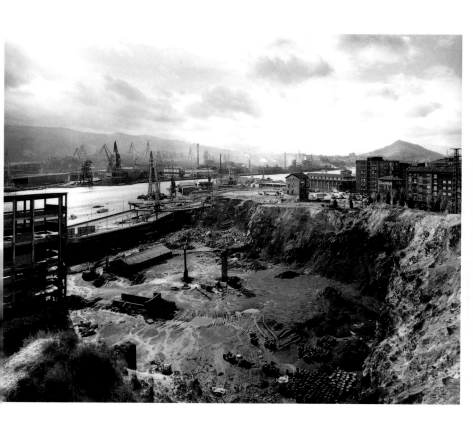

Madrid, Spain, 1993. In both historical and town planning terms, Madrid's Gran Via is the city's central, monumental street. The corner buildings, with their rounded ends, rise like pieces of sculpture, or the bows of urban liners. I decided to include in the composition of this image some characteristic elements of street language – the curved lights and zebra crossings that help to define space and emphasize the vigour of this city-centre architecture.

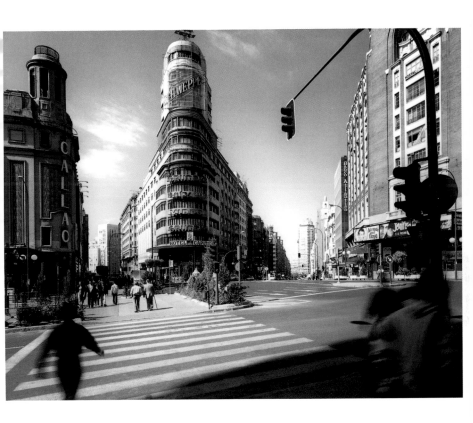

Oporto, Portugal, 1995. Contemplating the mournful beauty of the centre of Oporto, with Gustave Eiffel's iron bridge and the River Douro, it was as if one's sensitivity was heightened and one entered a timeless, elevated state. The evening light softened the contrasts and intensified the oiliness of the flowing water. It was an enchanted moment, a quiet pause before darkness fell.

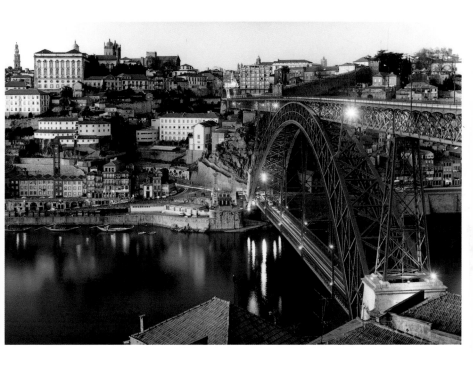

Milan, Italy, 1995. For various reasons, building in Milan was halted for many years. Then it began again, with new construction and the redevelopment of large public spaces. In 1995 I started this project of photographing my city again, taking as my starting point the idea of work in progress. It later became a book, entitled *The Interrupted City*. I think this image effectively expresses the mediocrity of many of the city's suburbs, both as examples of building practice and as places in which to live. The methodical care with which I photographed this place should not suggest a suspension of critical judgement but, on the contrary, should offer the possibility of deeper understanding.

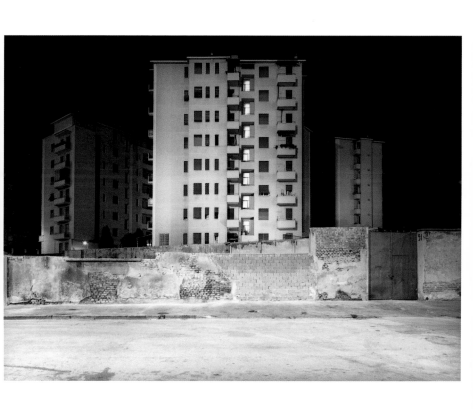

Milan, Italy, 1995. Even today, Milan bears the scars of World War II. As in other Italian cities, the process of reconstruction slowed down, in some cases to the point that work stopped completely. This special situation meant that, in certain corners of the city, the old and the new, different styles and periods, survived, as if in a surreal metaphysical puppet theatre. The central space in this image is a place that leads nowhere, hardly noticed by the people hurrying past it.

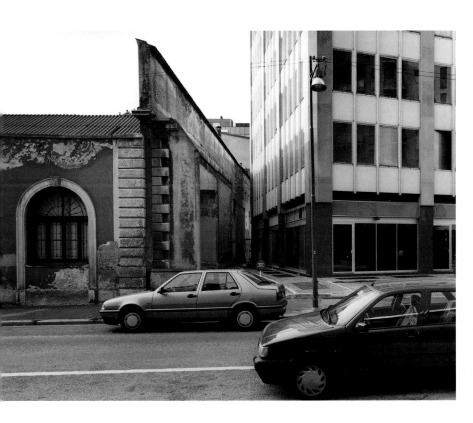

Milan, Italy, 1995. In my book *The Interrupted City*, I followed three photographic itineraries within the city. The district I studied most closely is a densely built urban area, squeezed between two railway stations, the Central Station and the Garibaldi Station, and almost entirely built just after the war. The building type, compact and with a pronounced tendency to the vertical, which was new for Milan at that time, emphasizes the appeal of a ubiquitous Modernism as the symbol of a city dedicated to commerce. My image is part of this tendency buildings crowded together with no breathing space, and only a small escape route above, where they can reach for the sky.

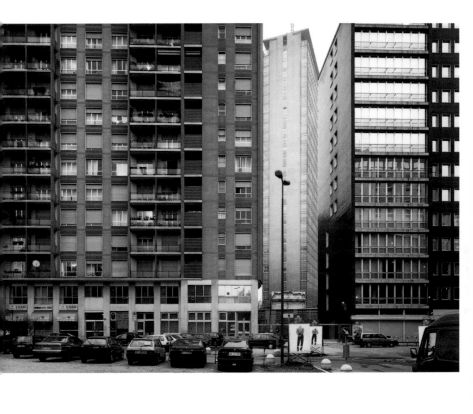

Milan, Italy, 1996. Piazza Missori is right in the centre of Milan. It was built in the 1930s, and is a typical example of the monumental style that transcends the architectural rhetoric of the period and effectively expresses the spirit of a modern city centre. As a counterpoint to it, the archaeological remains — tiny vestiges of the Roman walls that survive in the middle of the piazza — stand apparently undefended against the massive looming forms of the surrounding buildings.

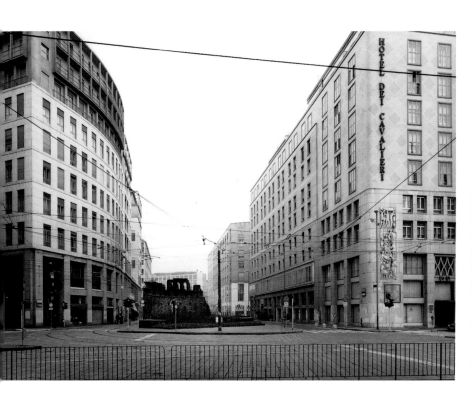

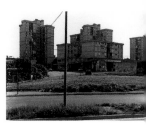
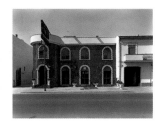
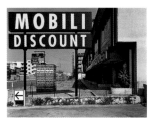
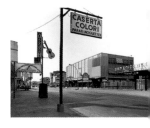

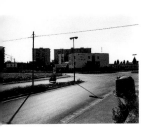
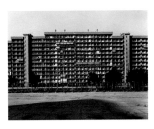
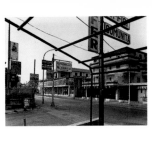
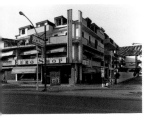
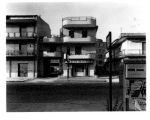
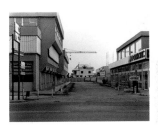

(previous page) Cross-sections of a Country, Naples to Caserta, Italy, 1996
This work was undertaken in collaboration with the architect Stefano Boeri for the 1996 Venice Biennale of Architecture. The intention was systematically to juxtapose six journeys or sections through geographically distinct parts of Italy. The areas chosen are never more than 50 km apart, and each journey links the outskirts of one big city with those of a neighbouring one. Our focus was the transformation that had taken place in Italy in the previous ten to twenty years. By placing the images close together, in the exhibition and the book, we were able to make a composite picture that revealed both differences and similarities in the anarchic way cities have grown in various regions.

Rome, Italy, 1997. The Piazza di Porta Maggiore, with its monumental entrance in travertine stone, now built into the long unbroken wall of the aqueduct. Tramlines and overhead electric cables, roadways and pedestrian pavements all go through this wall, with its double order of arches. Sights like this are one of Rome's odd and surprising features, fascinating tourists and delighting people like me, who are attracted by the confusion of visual languages and the layers of the city's history, superimposed and consolidated over the centuries.

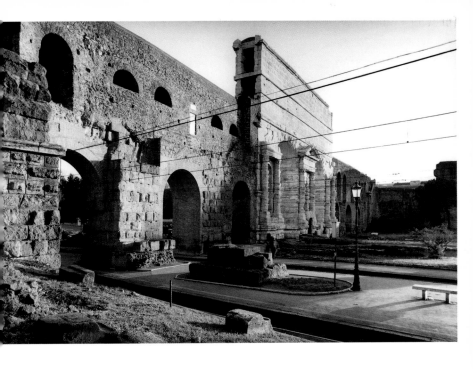

Guggenheim Museum, Bilbao, Spain, 1997. I was in Bilbao for the opening of the Guggenheim Museum, on a commission from a weekly magazine. Frank Gehry's creation — the most impressive and unusual museum building of the late twentieth century — had already been photographed many times, and many architects were calling it not a building but a large piece of sculpture. But I believe that even if its sculptural qualities are emphasized, it remains an extra-ordinary architectural phenomenon, like some enormous animal stretched out on the bank of the river. The organic forms of its body can absorb great numbers of visitors, who seem even smaller in comparison with the building's grand scale.

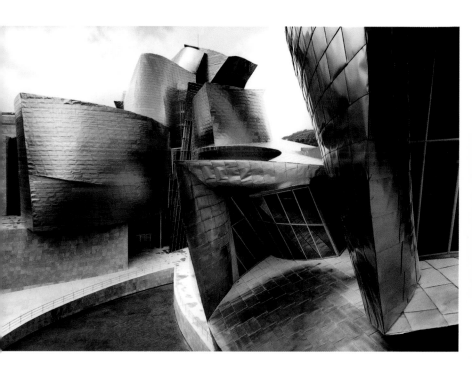

Paris, France, 1997. The contemporary architectural scene often resembles an artificial and deceptive paradise, full of pedestrian areas, skyscrapers, piazzas and buildings clad entirely in reflective glass. Its homogenized spaces are falsely described as being on a human scale and lack any but the most stereotyped identity, interchangeable and thus anonymous. In a district built very recently, La Défense in Paris, I wondered whether the natural attraction such places have for me might not be slightly ambiguous, and contain a faint, subconscious element of sadism.

Palermo, Italy, 1998. Imaginatively speaking, we often feel comfortable with clichés; take the case of distant cities we have never seen but nevertheless feel we know. For my exhibition 'Palermocittà', and the book that accompanied it, I decided to explore the city's modern districts, ignoring its better-known historic areas. Anyone looking at this picture would find it hard to believe that it is of the ancient capital of Sicily and not a modern northern European city.

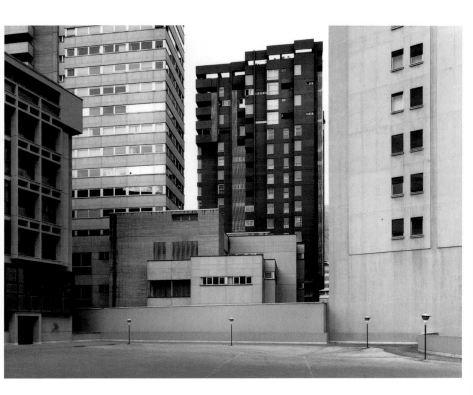

Palermo, Italy, 1998. This image of the historic centre of Palermo could symbolize a certain version of Italy, suspended in time, sunk in a deep sleep in which it seems impervious to any attempt to awaken it. There are situations about which it is easy, and justifiable, to make harsh critical judgements. But in my opinion, that is not enough; what is needed is deeper understanding and the opening of the sort of dialogue that taking photographs makes possible.

Colosseum, Rome, Italy, 2000. To mark the Jubilee Year of 2000, I was commissioned, along with a number of other international photographers, to do some work on Rome's aqueducts, from the outskirts of the city to its centre. Bureaucratic delays prevented me from arriving on schedule at the Colosseum, Rome's most spectacular and characteristic monument, which I saw as the final point on my itinerary. Its advanced design and monumental grandeur transcend its over-exposure as a tourist sight. One possible way for me to relate to this architecture-in-ruins is by studying its form, measuring and understanding its extraordinary physical qualities.

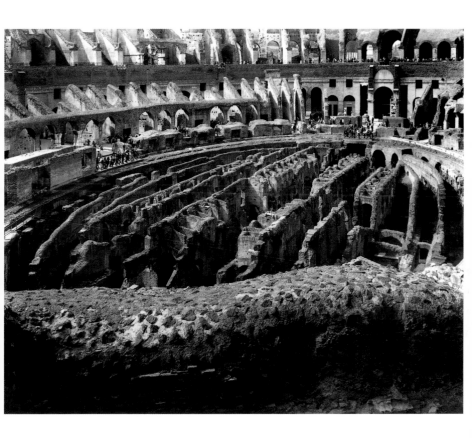

Arch of Constantine, Rome, Italy, 2000. A view of the Arch of Constantine, framed by the walls of one of the passages leading to the outside of the Colosseum. There is a sense of privacy and separation from the world, suggested by the two protective wings of the upper floor, and an illusion of suspended time and immersion in the past, since there are hardly any visible signs of contemporary life.

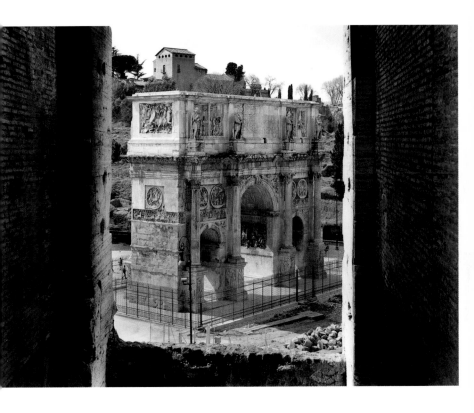

Berlin, Germany, 2000. I worked in Berlin from June to August 2000, following an itinerary that started from the border zone around the old wall, near Potsdamer Platz and the huge expanse of land covered in building sites, and then took a north-easterly direction along a narrow strip beside the River Spree. Of all European cities, Berlin has perhaps been the most renovated in recent times, in terms of architecture and planning. A number of ruins are left from World War II, fragmentary monuments to tragic events, as in this image showing what remains of a once great railway station, the Anhalter Bahnhof.

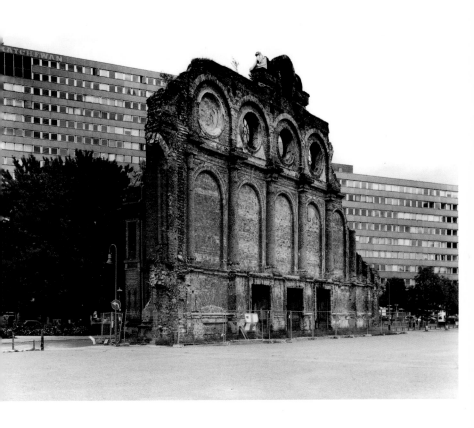

Berlin, Germany, 2000. This was not my first visit to Berlin, but each time the city has had a more powerful fascination for me. I was particularly interested in revisiting the East, and seeing the many changes that had taken place; but what drew me most was the still very pronounced contrast between past and present. Most of all, working in Berlin gave me the opportunity to test a way of looking at the city: the real, tangible, everyday city and the city as imagined and projected over the last centuries, which, especially in the East, still to some extent survives. The severity of these massive, grey nineteenth-century buildings, a symbol of urban order and authority, was already imprinted on my mind before I arrived in Berlin.

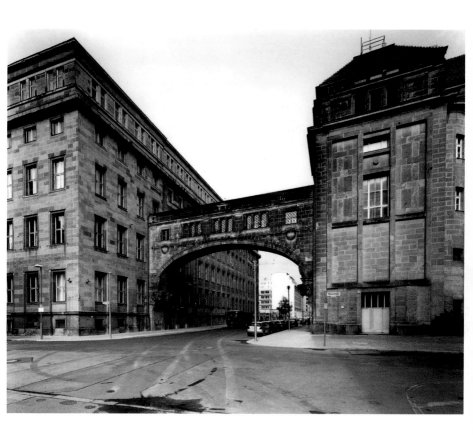

Berlin, Germany, 2000. The Gendarmenmarkt is one of East Berlin's historic central squares. Two cathedrals, the Französischer Dom and the Deutscher Dom, face each other and converse like the leading actors on the great stage formed by the square, in which the audience, around the sides, is largely made up of very recent buildings standing in neat rows. Once again, past and present fight for supremacy against a background of cranes, the ever-present image of Berlin in the new millennium.

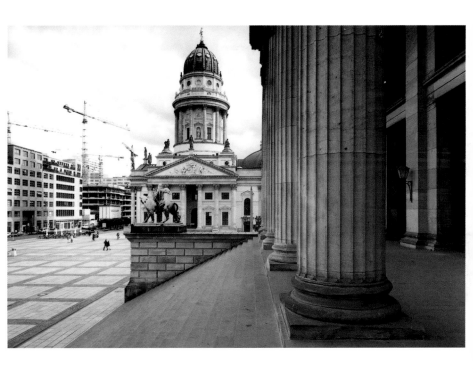

Berlin, Germany, 2000. Literature and history have often coincided at Checkpoint Charlie, the crossing-point between East and West Berlin during the Cold War. As part of the ultra-rapid transformation of the area, where a dazzling building by Kleihues rises on the corner of Friedrichstrasse and Kochstrasse, a large work of political art posted above the street recalls the presence of the opposing armies. There is no trace of the past here, but the images of the soldiers serve as a monument to the tragic history of a divided city.

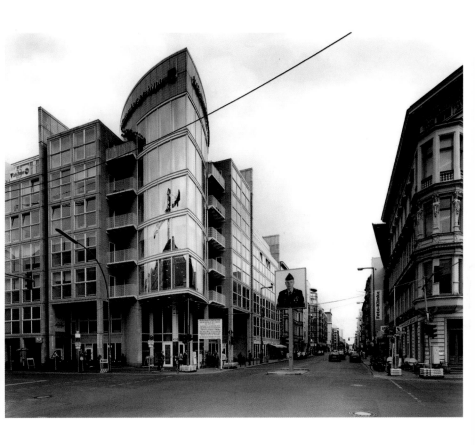

Berlin, Germany, 2000. Potsdamer Platz is not a reconstructed square, but a whole section of the city in the process of being rebuilt. More than any other place, it is an expression of the desire for change, demonstrating the capacity of Berlin's financial backers to undertake enormous development projects. Their scale represents a turning point in the city's history, in that the density and height of the buildings are new, and mark a move away from a traditional preference among planners for horizontal growth and big distances between buildings.

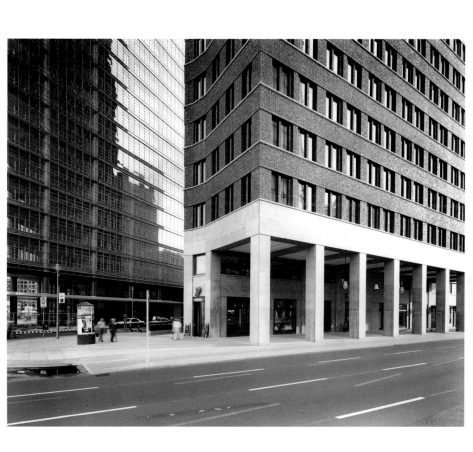

Berlin, Germany, 2000. The Siemensstadt complex is a city within the city. Everything seems to fit the definition of factory style, blending rigour, order, monumentality and functionality. The façades are austere and severe, the spatial rhythm perfectly regular. Then you suddenly have two trees, framing the entrance to one of the office blocks with a natural symmetry. Its a pleasant, gentle touch. I'm photographing an image I have seen before; it's a quotation, but I don't know from what.

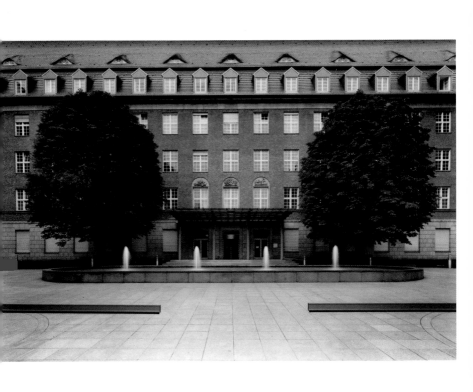

Berlin, Germany, 2000. A large square in Lichtenberg, in East Berlin. The size o
the space, and the absence of movement, allow me, as sometimes happens, to
make an idealized visual reconstruction of this place. For me, a place in a photo-
graph, even this apparently cold, taciturn place, is always the outcome of the
meeting between closely observed reality and the reality of the imagination
which intersect to create a new dimension, a different reality.

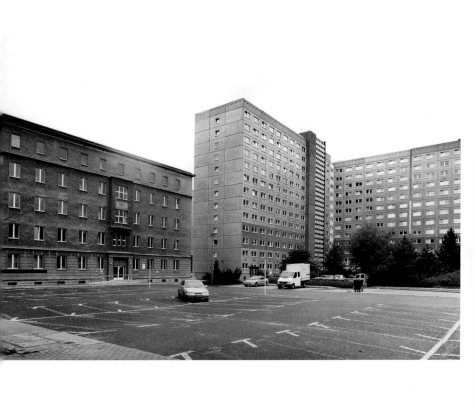

1944 Born 12 August, Milan, Italy.

1973 Graduates from the Faculty of Architecture at the Polytechnic of Milan.

1978 Begins detailed research into the urban industrial area of Milan.

1983 His research culminates in the exhibition 'Milano, ritratti di fabbriche' at Padiglione d'Arte Contemporanea, Milan.

1984 His work is featured in the group exhibition 'Viaggio in Italia', based on a project by Luigi Ghirri on the contemporary Italian landscape.

1987 Solo exhibition 'Italia–France' at the Rencontres Internationales de la Photographie, Arles.

1988 Begins a series of commissions for the Province of Milan.

1990 Receives the Grand Prix Mois de la Photo, Paris, for his exhibition and book *Porti di mare*.

1991 Participates with a group of international photographers in the Mission Photographique on the city of Beirut.

1992 Solo exhibition at the Musée de l'Elisée, Lausanne, Switzerland.

1993 Solo exhibition at the Printemps de la Photo, Cahors, France.

1994 Receives another commission to photograph the city of Nice, France. These images are then exhibited at the Musée Matisse. Has retrospective exhibition 'L'esperienza dei luoghi' at the Fondazione Galleria Gottardo, Lugano, Switzerland.

1995 Starts new research project in Milan which becomes the subject of his book *The Interrupted City*.

1996 Receives two commissions for the Venice Biennale/6th International Exhibition of Architecture, one from the Swiss Federal Cultural Office, and the other from the Italian Pavilion. Receives the Osella d'Oro prize at the Venice Biennale for best photography in the field of contemporary architecture. Invited by the Kunsthaus Zürich to